CW01033610

Dear Pam,

happy birthday! How wonderful to have you stay — and to see you happy.

love
Christine

Oh joy, oh ecstasy
To climb high above a forest canopy
And dance with dragonflies in a temple in the sky.
To walk on sunshine
And have butterflies bear witness,
To the shedding of ego and embracing of soul.

— Ta Keo Temple, June 2008

Beatnik Publishing

PO Box 8276, Symonds Street, Auckland 1150, New Zealand

First published in 2013 by Beatnik Publishing in association with Christine Spring

Text: copyright © Christine Spring 2013
Editors: Brynne Clark & Frances Chan

Design, Typesetting & Cover Design: copyright © Beatnik 2013
Designer: Kitki Tong
Illustration: Elaine Loh

Photographs: copyright © Christine Spring 2013

Printed and bound in China

ISBN 978-0-9922493-3-5

For the women who have touched my life –
but especially for my mother, sisters
and sisterhood of girlfriends.

Thank you all for your love and encouragement.

INTRODUCTION

I believe in life we are presented with precious, rare moments of serendipity that offer us an opportunity for growth, love and happiness – if only we have the ability to recognise them and the courage to believe in them. For me, serendipity arrived in April 2008 via a storm, a party and a sculpture. Unexpected, yet with blinding clarity, a light shone on my life and illuminated the need for major changes. Having found the courage to be honest and truthful with myself, I became determined to make a long-held dream come true – to live in Paris and study photography.

At first, my mind (my ego) railed at the thought of change, and my soul's voice was smothered as I countered emotion with logic. Faced with self-defeat, I needed to find space to quiet the logic of my head and allow the desire of my soul to speak into the silence. The temples of Cambodia beckoned, and I went to meditate. On my last day in Siem Reap I climbed Ta Keo Temple at dawn and wrote the words of the poem 'Oh joy, oh ecstasy'. My choice was made.

At photography school, I was asked what form of photography I hoped to undertake, to which my immediate response was 'fine art'. I had drawn sketches of women's bodies when I flew to Siem Reap. I had a personal collection of paintings and sculptures that all focused on the feminine form. It seemed that in looking at images of women, I learnt to better understand myself. I knew that I wanted very much to photograph women – with my personal vision – to illustrate their sensuous, sensitive souls.

I conceived the idea of creating nudes from a female perspective focused on the inner sense of self. I imagined them showing a woman's strength, her vulnerability, her courage, her passion and her magic. I desired to create images that spoke of spine, self-worth, personality and depth of character. I wanted to remove the aspects of ego and judgement, and enable each woman to focus instead on a perspective of herself that is often ignored: the beauty of her soulful nature, set in a location that she connected with, and at a time of her choice.

Often the time and location chosen provided only a slim opportunity to capture an image. Time had to be juggled with work, family and other obligations. Alone, I would present myself without flash, reflectors or an assistant. The aim was not to strive for perfection but rather the beauty in the chosen moment.

This project was not about photographing the ego aspects of faces, breasts and genitals that we are so often judged on, but

rather celebrating the extraordinary beauty of soulful women. The series of images are of women in their 20s, 30s, 40s and 50s, and were taken on four continents over the course of 13 months.

The majority of the images were taken outside and required the women to place their trust in me – I was humbled and honoured that they did. It was fabulous to hear most women exclaim afterwards how liberating the experience had felt! I imagined it as a liberation of soul shining in its glorious self, free (albeit for a few moments) from the ego's constraints, the judgement of others and the dreaded tyranny of 'should' and societal propriety. In striving to capture the beauty of the moment, rather than absolute perfection, we were both able to relax, go with the flow and enjoy the wonderment of a serendipitous moment when light, circumstance and energy collaborated.

Each woman explicitly understood that I would not 'touch' her body shape during the development of the final image. There would be no removal of cellulite or wrinkles, no electronic magic slimming diet. As I commenced the project with the goal of creating a portfolio of black and white classic images, I found that the personality and energy of each individual woman and location 'spoke'. It was as if each woman's character was affecting her

image and I found (much to my surprise) that for some images, colour and vibrancy were integral. I chose to relax and not resist the instinctual need to adjust colour where it felt required.

Having captured the images, I sought to align them with my personal philosophy on the many aspects of a soul's journey towards liberation. These words are my thoughts, formed during my own journey. They are in no way intended to comment on a specific person or to be about the particular woman in an image. Instead, the image is intended to complement the text, as a form of visual beauty for reflection on the words expressed.

I will always be most grateful to the women who supported me in this project and to those who agreed to model. Some were sisters, many friends, some sisters of friends, some strangers and a few were women who saw my work and contacted me for a sitting. To each of you, I offer my thanks.

– Christine

SHE IS WOMAN

She stands.
Straight, strong, confident,
Her nakedness is not her shame it is her pride, her self-worth.
She is Woman.

She is one, but of many parts.
Each an expression of experience,
Her feelings and form reflecting environments endured.
She is Woman.

She is resilient.
Inner strength formed of steel.
Her body warm and smooth to touch.
She is Woman.

She is fragile.
Support, care and love required.
Her internal balance a core of grit and determination.
She is Woman.

She is beauty.
Unique, exquisite, captivating and rare,
Her manner mesmerises, yet modesty pervades.
She is Woman.

She is me.

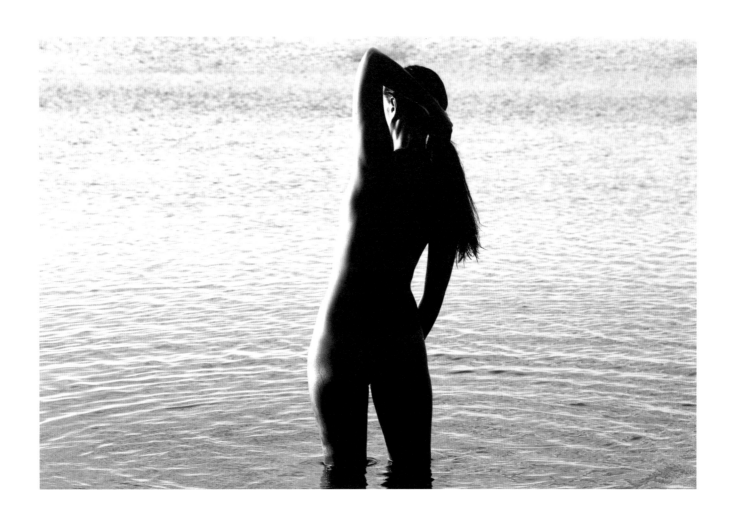

AWAKENING

Born with a body, mind, heart and soul, the human point of difference is the ability to develop each of these elements and to 'create' our unique self.

First, the body receives instruction – walking, talking and toilet training. We swiftly learn that our body is an instrument capable of accomplishing all manner of physical feats. We also start to appreciate its limitations and where our innate physical capabilities lie.

With schooling, the systematic training of our mind begins. We are encouraged to apply ourselves and to strive for success. Over time, we start to recognise our natural talents, our passions and our inclination to further develop our mind with knowledge.

Yet, with the training of body and mind comes the development of our ego and sense of self. Am I competitive? Am I a natural leader or do I prefer a team environment? Do I hunger for praise or prefer to disappear into the background? In time, the questioning extends. Is everything all about satisfying the demands and expectations of parents and society? What about following the path of our own unique dreams and desires?

Do you listen to the calling of your heart, of your soul? When during our journey, if at all, do we consciously seek to define our unique self in terms of passion and our spiritual destiny? Are we too motivated by a need for safety, security and success to spend time cultivating our spiritual well-being?

At what point in our life will we awaken to the needs of the soul and seek to balance them against the demands of our ego?

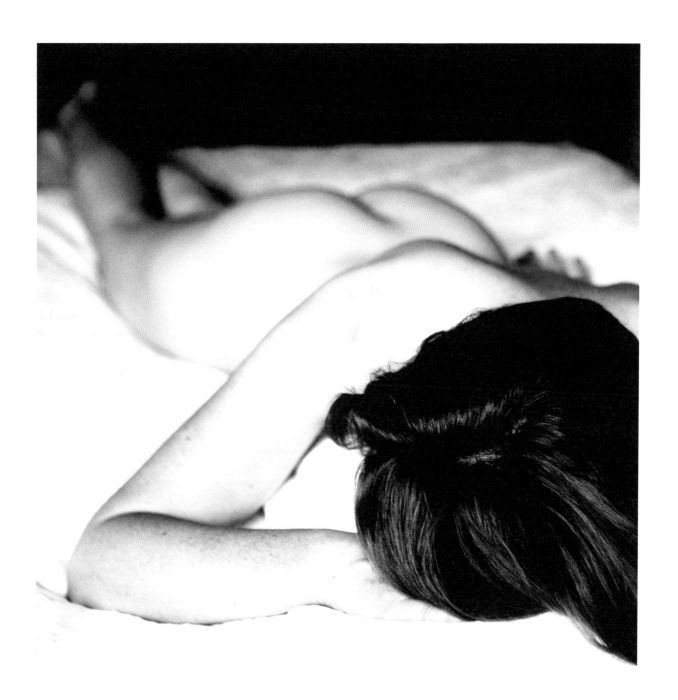

HESITATION

For millennia, the development of the soul and our 'sense of the sacred' were largely formed by religious instruction. Our souls were moulded by the religious persuasion of our parents and the society we were born into. Little choice was given as to the doctrine received and rarely did the opportunity arise to consider alternate philosophies.

The teaching of religious doctrines sought to guide the development of societal values and establish fundamental mores for living in communal harmony. However, as with many aspects of life, the original intent has, at times, been detrimentally affected by human failing, desire for power and control and/or misinterpretation. One such common distortion is the concept that redemption is best achieved with 'God-fearing' behaviour.

The principle of fear has been repeatedly utilised throughout history as a great control mechanism of behaviour. Yet fear is not a good way, or indeed any way, to develop the beauty of a soul. It may be useful for defining guilt and a tool for curbing 'sinful' behaviour, but living in fear does nothing but diminish a soul.

It is when we face our fears that we build courage, resilience and soul strength. This is why it is so important that parents and any religious instruction teaches children self-worth, self-love and self-esteem.

When we awaken to the needs of our soul and seek to balance them against the demands of our ego, we need to take the time to stop – to hesitate in our haste. Before we rush to make change, we need to be strong in our understanding of whose values we want to align our life with – our parents, our society's or our own?

Hesitation often comes with the realisation that an individual soul develops with reflection and self-understanding, not just to others' standards and desires, but also to an appreciation of its own. It is how we are able to live life being true to self, yet also in harmony with a chosen community. As human beings we have choice, so the question then becomes 'Do I have the courage to live true to self?'

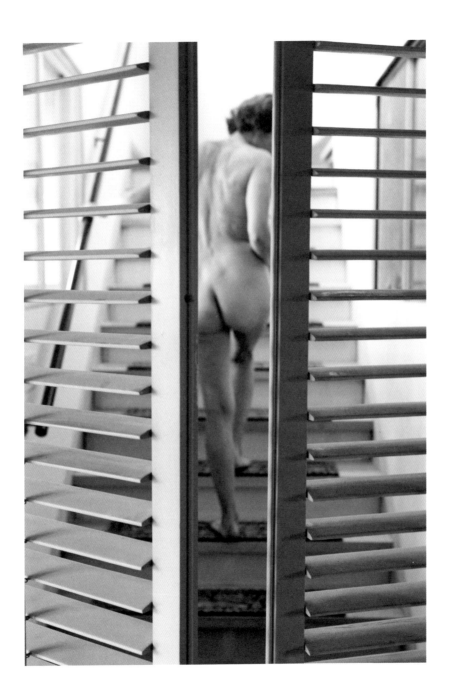

PROCRASTINATION

If little time is spent in childhood learning about the soul's role in our life, it is not until adulthood, away from the omnipresent influence of parents and societal pressure, that we start the slow process of soulful growth. When there has been so little preparation, it is not surprising that we make mistakes. We stumble clumsily, and ideally, we learn a little with each stumble. If we do not, we continue to repeat our mistakes, until finally the learning occurs.

The trouble with this internal 'soul-searching' is that it requires self-awareness and an honesty that often we would rather shy away from. It is hard sometimes to look at ourselves in a mirror and see ourselves as we truly are, when it is so easy to see only the illusion, a plastic mask of the person our ego prefers to project.

Is this why we so admire people who have the strength of character and soul to live true to themselves? Throughout history, we have honoured those who did not sway from their great commitment to their personal values, and to the truth of their souls. Sir Thomas Moore, Mahatma Gandhi and Aung Sun Suu Kyi typify this strength of soul commitment. Their paths were not easy, not without fear, but unwavering in the choice to live true to self.

Inner peace and freedom come when you stop living with a plastic mask, stop trying to live up to someone else's expectation and, despite fear, choose to live true to self. The shedding of a plastic mask is painful, often akin to a rebirth. It is natural to procrastinate, to try to postpone the pain. Nevertheless, once you are honest with yourself, it is hard to remain buried behind a mask.

We are unique, individual creatures who are here to evolve and to develop our souls during our journey on earth. How do we motivate ourselves to stop procrastinating, get moving and live a true life?

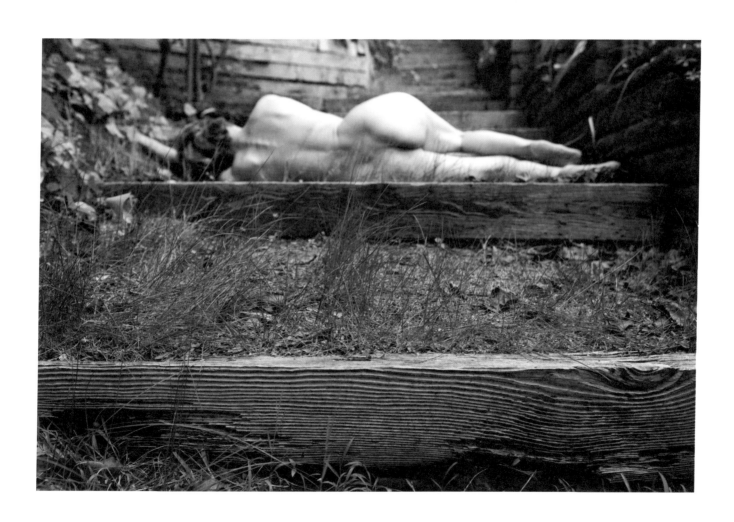

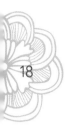

ENERGY

In life, there are so many choices available to us, so many opportunities. The question is what type of person will we be. One who prefers just to speak of choice, or one who prefers to act on choice?

It's easy to sit on the sidelines and provide comment – safer, perhaps. If we don't engage, we limit our risk of getting hurt or making a fool of ourselves. However, if all we ever do is speak, critique and comment, are we actually living, or do we simply exist?

For those willing to expend energy and risk failure there is the opportunity for success, accomplishment and joy. These people embody the adapted words of Theodore Roosevelt[1]:

Far better is it to dare mighty things, to win
glorious triumphs,
Even though checked by failure...
Than to rank with those poor spirits who neither
enjoy much,

Nor suffer much,
Because they live in a gray twilight that knows
not victory,
Nor defeat.

The Universe responds to our energy. When we start to take action, things often happen, as if circumstance were conspiring to help us achieve. Rarely do we get what we want just by thought alone.

The expenditure of energy and a commitment to focus are the traits of all great sports people, entertainers, artists, scientists, business people, explorers and those that live magic love stories. Why then do we sometimes shy away from making an effort? Why can we be so resistant to expending energy?

If you never try, you will never know what you are capable of achieving. Choice in life is meaningless if we do not also have the attitude, energy and commitment to act on our choices.

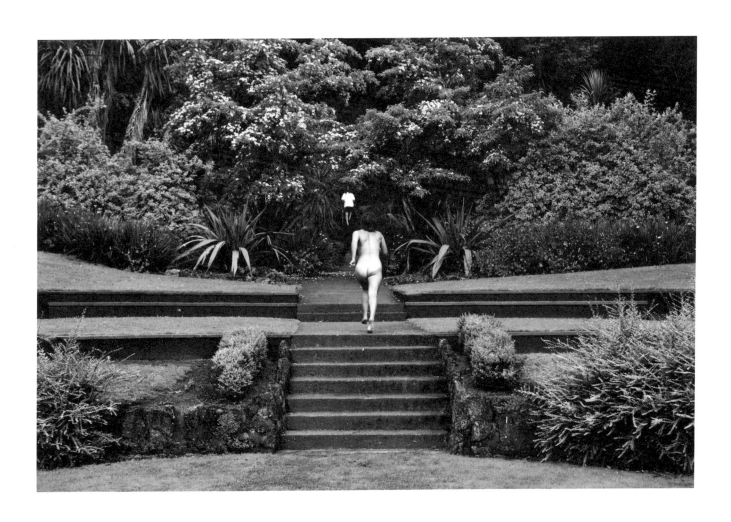

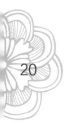

ENVIRONMENT

No matter how we are nurtured as children (and later as adults), the environment that we inhabit will always affect us. It shapes our thinking and our sensibility, our opportunities and our choices.

Our environment often outlines for us the boundaries of duty and obligation. It seeks to define societal expectations for our behaviour and responses. It is our knowledge of these expectations that creates in us the understanding of 'should'. We commonly use 'should' when we feel the pressure of duty and obligation – yet in our hearts and souls, we desire an alternate course of action.

It is difficult to journey away from the path of 'should' and choose instead to satisfy one's own innate purpose and quest. It is a choice often judged to be selfish, thoughtless, self-centered, insensitive and rebellious. It is a choice that often scares others.

The truth, however, is the opposite. To journey 'inside' oneself and away from the path of 'should' takes courage and effort. It can result in stumbling, confusion, mistakes and pain. It can often be lonely and isolating.

It's at times like these that we can take comfort from the analogy that daily the world weathers wind, rain, sunshine and cloud. No matter what the storm, the sun sets and then rises again to meet a new day. With faith in ourselves, we too can build the strength to weather the many difficulties of our journey, knowing that this is the only path for soulful growth. Equally, we can also decide if the current environment that we inhabit is good for the growth and well-being of our soul. If it is not, perhaps we need find a more conducive environment, or try to limit our exposure to our existing one.

Fortitude to believe in oneself takes commitment to journey inside – to find the peace within and to explore our inner beauty. When we choose to live true to self, we acknowledge the uncertainty of the environment ahead, but have faith that our values and life purpose will guide us through good days and bad.

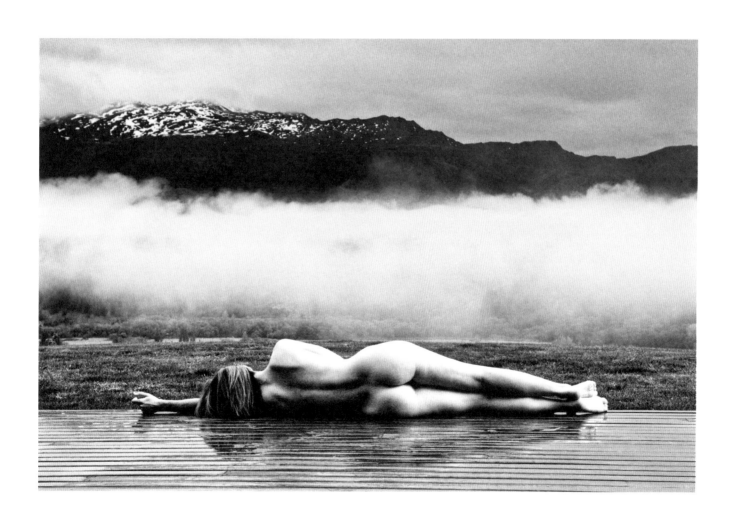

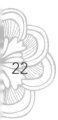

NURTURE

For many of us, life's journey and purpose includes the roles of parent and nurturer. Invariably, we willingly embrace the demands and sacrifices of these roles. It is natural and instinctive to want to protect and nurture our children, our family. It is understandable that we would want to give our children all that we can, all that we did not have.

Where, though, in our thought process do we place ourselves? In choosing to give our children our undivided attention, what energy remains to nurture our self, or to nurture the love in our marriage, the love of our partner?

What motivates us to put all of our effort into our children? Do we subconsciously desire our children to be more perfect than we have been? Is it easier for us to 'work' on their growth, rather than to continue to work on our own? And why do we not recognise the danger of ignoring ourselves, ignoring our partners and ignoring our marriage? Why do we forget that love is the foundation of our relationship, the foundation of family, and that the love between the parents also needs to be nurtured?

We women often look at men and derisively mock their midlife crises. Perhaps instead we should take heed. The midlife crisis is a reawakening to the reality that life is short. It is a time when choices are reviewed, a time when truth to self often arises, and values and desires are reassessed. If we have chosen not to nurture ourselves or to nurture our relationship, our marriage, why then should we be surprised when our spouse chooses to seek love and affection elsewhere? In life we need to nurture, but our souls also need to be nurtured. Trouble brews when we forget to nurture ourselves and those we profess to love.

DREAM

Who are we to say which dreams are logical, and which not? To be true to self, should we not strive to experience the magic and joy of a dream come true?

Dreams do not need to be big to be fulfilling. A wistful dream may simply be to 'lose' ten kilograms. It will require strength, will power and commitment to achieve this dream. Perhaps a change of eating habits, a commitment to daily exercise. But if being ten kilograms lighter is your dream, then it is the combined power of your will, soul and intelligence that can finally give you the strength to achieve what has previously been unachievable. Realising this dream is not about denial, restriction and sacrifice, but rather a very personal journey towards love of self, commitment to self and self-worth.

What if we chose to live the mantra 'dream it, believe it and achieve it'? What results could we achieve with a 'vision board' of us now, and us as we wished to be? Would it help us focus on our dream? Would it strengthen our will power and resolve to kick old habits and norms? Do we truly believe that we are free to choose and that we are not 'tied' to the cappuccino, the daily glass of wine and the chocolate bar? Imagine the euphoria as the kilos start to disappear. Imagine the abundant pleasure of having achieved this dream.

Do our speech habits undermine us? We talk about 'losing weight', but the word 'loss' has a negative connotation with grief. If our weight reduces, will we grieve the loss of our old self? Are we worried that if we lose the weight we might want to find it again? Why do we fear being all that we can be? Why can we not revise the context of our thoughts to gaining the incredible gift of ten kilograms of freedom and self-esteem? By reframing a reduction in weight as a 'gift to self', we could reprogramme our minds to wanting and desiring this gift.

With faith and belief in our unique self we can achieve our unique dreams – the only question is how much do we want and believe in this dream. Do you believe you are worthy?

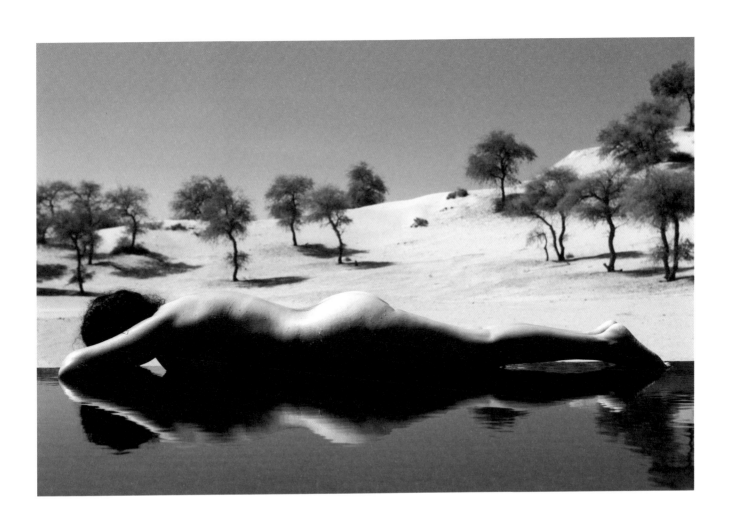

TRUST

Sometimes there can be so many voices inside us. The noisy voice in our head that shouts the logic of our mind, the instinctive voice in our stomach that resonates with our soul's knowing, the tense voice across our shoulders that grips us painfully in stress, and the voice of others' judgement that blasts through our ears. How do we learn which voice to listen to?

Sometimes it feels as if you have been placed within a field of maize. You stand alone, isolated, and unable to see a way forward, but with all these voices surrounding you, and encouraging you to move in all different directions. But if we are forever listening to these external voices, when do we learn to trust in our own voice? We can learn from others, we can listen to their advice, but eventually we need to quiet their voices to be able to hear our own.

Yet, once we have silenced the noise in our ears, and put aside the pain in our shoulders, there remains within us the voice of our ego, and the voice of our soul. Ego is clever. It uses logic and cold reason to form its arguments. Ego often speaks of safety, security and placing your trust in others.

The soul, however, has a quieter voice; it speaks with feeling and resonates within the instinctive gut. It whispers of our dreams, loves and 'higher' purpose. The soul does not speak of safety, but rather of risk. It makes no promises. It asks you to fully trust in yourself, to believe in yourself.

To be your wholly authentic self and to live your life's purpose, you need to be able to listen to your soul's wisdom and trust in yourself. Trust your instinct, trust your judgement, trust your choices, and life can be extraordinary.

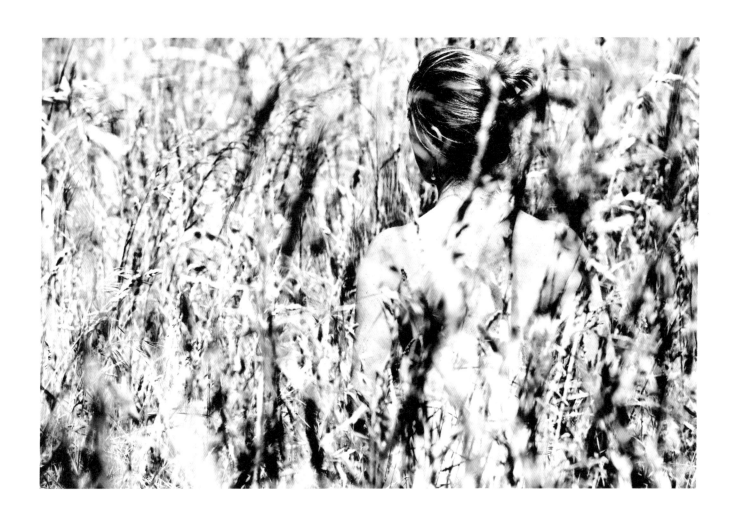

HOPE

Hope is the spiritual strength that keeps us moving, keeps us in action towards achieving whatever we desire. Without hope, the will to act can be lost; the desire to fight despite the odds, eroded.

While optimism can reflect our ego's confidence, hope draws on the strength of belief we hold within our soul. It is the hope in our hearts that helps us believe in tomorrow, believe in our goodness and believe in our future. It is hope that helps the sick fight illness, it is hope that keeps us searching when a loved one is lost. It is the renewal of hope that comes to our aid as we fight our way out of a black depression, and it is hope that helps us work to create a better life.

Hope is born in the soul, empowers the heart and is strengthened through spiritual growth – our belief in a Universal spirit, God

if you will. If our development is limited to physical and mental education, how does our spirit grow? Will it simply depend on our own learned experience? How can we support our soul if we don't believe in hope? Surely, it is not just a word to be used when we buy a lottery ticket and wish for a better life?

Hope is an innate belief that charges us to take action and expend energy, to use our life force to deliver our dreams. It is the energy that can help us to be happy in the moment and what holds us strong when our body tires and spirit flags. Our lives may not be perfect, we may be exhausted, fearful, saddened, lonely and depressed, but if we have hope, we hold a candle that sheds light. Even a flickering candle holds light, all we have to do is protect it while it strengthens.

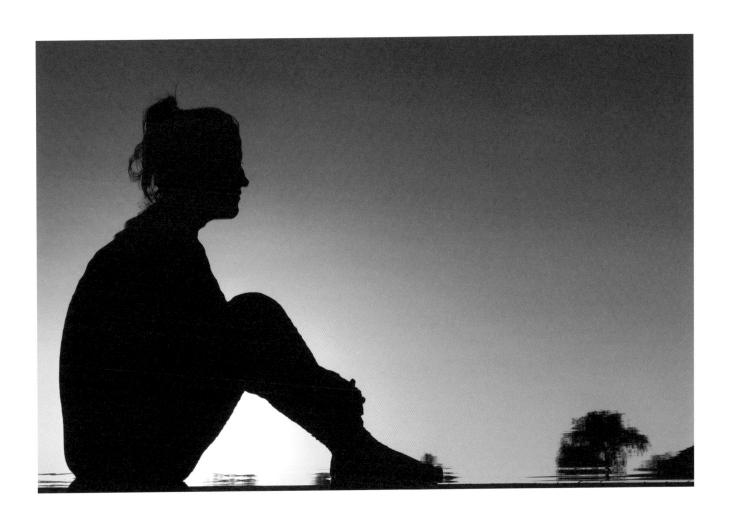

COMMITMENT

If we truly believed that marriage was about honesty, respect, communication and supporting an individual's soul growth within a loving partnership, would there be less romantic illusion about the commitment we are making on our wedding day? What if rather than planning a grand ceremony, a couple spent the months before their wedding discussing, planning and agreeing on their joint approach to marriage? Would there be less delusion, depression and divorce?

If we put aside for a minute our body's lustful demands and ignored our ego's need for adoration, we could perhaps take some time to listen to the desires of our soul. On the day of our wedding, what does our soul hope for? An ego union premised on safety, security, wealth and status? Or a true union of two souls?

If we decide not to trade traditional wedding vows, what vows of behaviour do we make? Do we openly commit to working at the relationship on a daily basis so that it can be the best it possibly can be, a soulful union based on respect, honest communication, unconditional love and support – not a business agreement, but a commitment to evolve and grow together?

In the face of disappointment, why do we use silence to create separation? Why do we let anger and resentment grow like an abscess in the skin of our marriage? Why do we wait until the cusp of suffocation – when we are at our weakest, when we make mistakes and have reached our tipping point – to find the courage to speak our truth? At this point pain is inevitable, for all.

When a soul faces suffocation it has two simple choices: accept the death of self, or fight for life. When we marry, we do not commit to accepting the death of our soul, no one has the right to suffocate another. When will we learn to put aside romantic fantasy and embrace a little pre-wedding reality? Do we realise this is our one life we are dealing with?

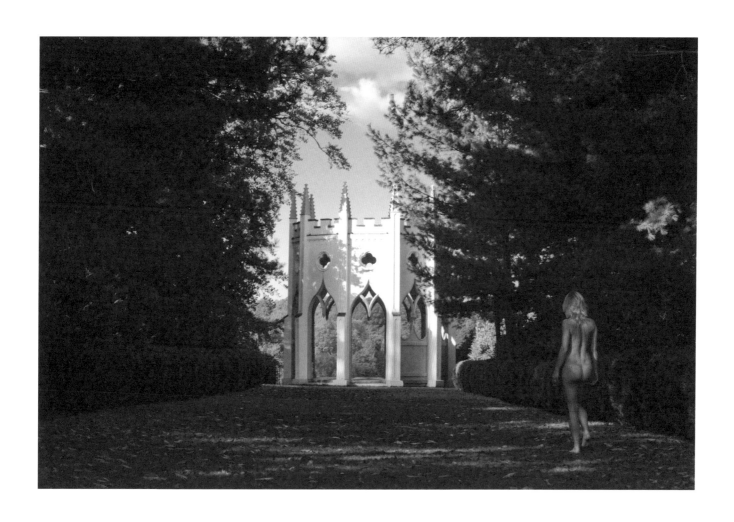

FORGIVENESS

There are times in our lives when it seems as if the Devil himself is guiding and encouraging our choices and actions. When no matter what our intuition tells us, no matter that we instinctively know the choice will lead to pain for others as well as ourselves, we cannot stop. Our choices and actions are guided by desire, passion, lust, loneliness, suffocation, fear or envy – an ego-driven need for the experience. All balancing aspects of reason, consideration for others and soulful intuition are either ignored or silenced. It is as if we can foretell the train wreck, but cannot look away, and are mute to raising a warning within ourselves.

It is only when the experience has ended, when the ego has retreated, and the 'fallout' has negatively affected both ourselves and others that the full impact of our action dawns. From this moment, we have three choices. We can choose to simply not care about any pain we have caused. We can cover our nakedness (our truth) and retreat into a dark space where we submit to self-flagellation. Or we can stand in front of a mirror, look ourselves in the eye and honestly admit, 'I have made a mistake, I have wronged another, I have hurt myself and I need to seek forgiveness for the pain I have caused.'

The path of forgiveness is not easy, but it is the only way to inner peace and soul growth. It requires an act of courage to stand in front of those you have hurt, and to seek their forgiveness. They are not required to give it, but if they have love and compassion in their hearts, forgiveness will come – albeit with time.

The harder task is to find the love and strength within to seek forgiveness from your self. Perhaps it is easier to chastise our 'badness', but ultimately, this is only self-indulgence, avoidance and self-imposed suffering. Nothing is gained. No growth can occur. Forgiveness of self requires self-acceptance, and is an act of self-love for both our ego and soul.

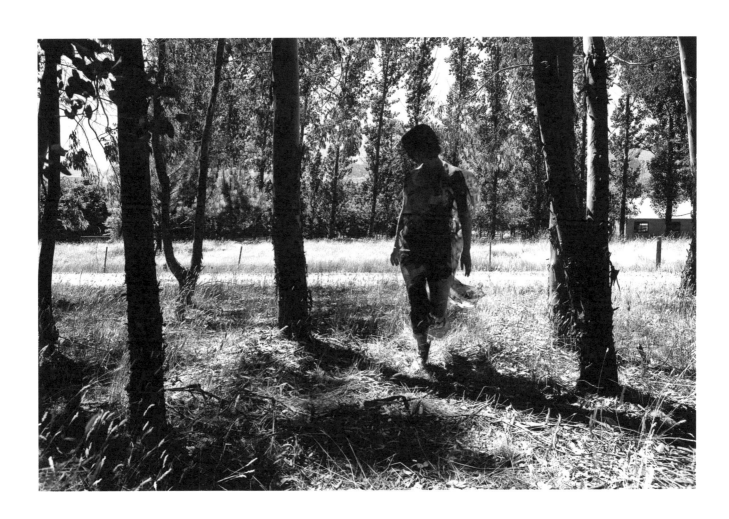

ACCEPTANCE

Some people project a strong sense of self. It is as if they were born with an iron-rod backbone of self-esteem and self-worth. It is not for them to be bullied into silence. For others, self-acceptance needs to be learnt through the development of self-love. It is what helps us define our boundaries to others; it is what helps us define ourselves.

Acceptance of self is not about believing that we are perfect, it is about being realistic and honest to our strengths and weaknesses. Acceptance comes when we no longer hold our head in shame, but forgive ourselves for our mistakes and choose to love ourselves despite our differences and imperfections. When we choose to accept self, we choose also to be accountable for our decisions and actions. We no longer seek to blame others for our life, for our situation or for our experiences.

Acceptance is hard. It requires us to embrace honesty, forgiveness and truth to ourselves, and to others. It takes energy and commitment. It can be draining. If you accept yourself, then you expose yourself to the judgement of others. What if they find you wanting? Unloveable? That is their choice, perhaps also their loss.

Why should we accept someone else's version of who they think we should be? We all crave love, friendship and understanding, but surely it is better to be loved for who we are, rather than for who we project ourselves to be. If we love and accept ourselves, we will never be without love in our life.

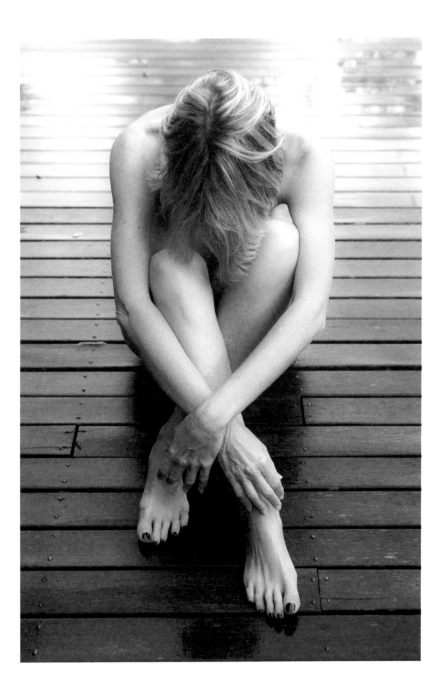

CONFIDENCE

There is nothing more attractive than confidence. To see a woman shining with her self-acceptance and self-worth is magnetic in its appeal. You want to be closer to her, listen to her, and learn her wisdom. You want to understand how it could be that she possesses this wonderful belief in her glorious self.

The self-confident woman is not arrogant; she does not need to be. She stands tall with her shoulders back and does not feel the need to make excuses for that which she is. She does not cower in the shadows. She has achieved an acceptance of self that so many of us struggle to achieve. She does not heed your judgement, your criticism or your comparisons. She is honest to herself and loving of herself. She strives each day to be the best she can be and is forgiving of her failures and her weaknesses. She is extraordinarily attractive, glowing with love.

Confidence is not knowledge for the ego to learn. It is an emotion, and a feeling within the heart and soul. It is an expression in behaviour of the soul's maturity. Confidence is gained with experience and the taking of risk. The more we do something the more we gain confidence – a belief that we can achieve, that we will be safe.

We each have within us a basic instinct for survival that engenders the 'fight or flight' response. It is confidence that gives us the ability to stand firm and 'fight'.

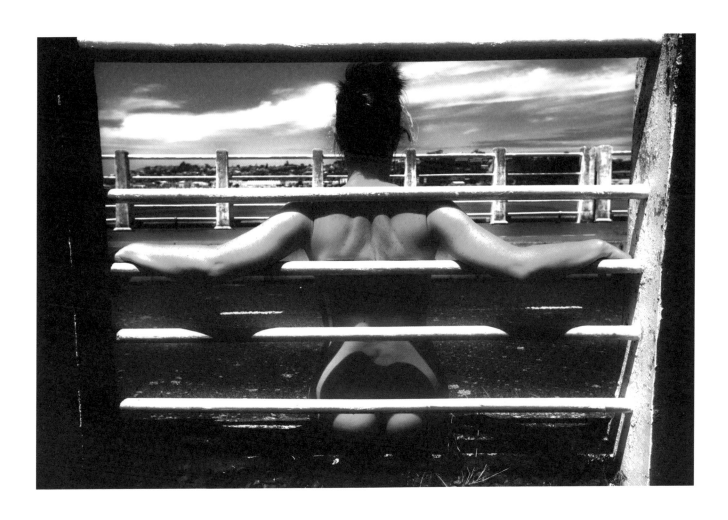

ALLURE

In an age where plastic surgery is readily affordable, image industries voraciously encourage us to eradicate wrinkles, shrink fat and inflate breasts. Bombarded with models of 'perfection', our egos are indoctrinated to fear judgement and relentlessly pursue the 'ideal' body.

Today, pre-pubescent girls impatiently await the arrival of their budding breasts, anxious to don a bra and display cleavage. Twenty-year-olds schedule facelifts and bodies undergo the rigour of boot camp. No matter what the age of a woman, there is now an almost religious observance to maintaining the sexual appeal of the body. As if feminine self-worth is merely defined in terms of youthful appearance. How could we have allowed this to happen?

In contrast, the myth of the alluring and sensual Parisian woman is not due to her physical uniformity to a celluloid ideal. Rather it is defined by her self-confidence. Her intrigue is not in what she chooses to display, but in the way she holds herself, and her faith in her unique beauty. She excites the senses and makes you wonder. She is not trying to be a mirror image of anyone else, but rather wholly and honestly herself. This confidence exudes itself in her bearing, her walk, her manner and her charm. Her self-love abounds and in union with her unique self, her soul shines its beauty.

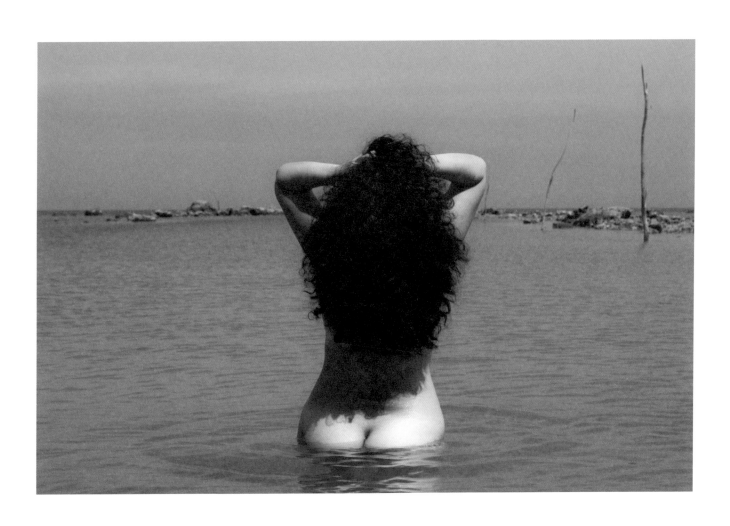

CONTEMPLATION

Each year we are encouraged to undergo health checks, which monitor our physical well-being. The simple tests enable diagnosis and early identification of any need for treatment. They are sensible, preventative steps for avoiding major disease. Yet, do we take the same measures to also monitor our spiritual wellness?

When, if ever, do we slow down, breathe and meditate? How often do we make the time to sit and ponder a conundrum in our life? It may be more efficient to google someone else's answer to a problem, rather than wasting precious time contemplating your own. But if we are always relying on someone else's wisdom, how will we ever develop wisdom and know our own truth?

Contemplation, be it through meditation, prayer or sitting quietly in thought, can provide the peace needed for the soul to express its truth. It is a time for growth and understanding, when spiritual wellness can be monitored.

The question then becomes what to do when enlightenment occurs. Is it enough to hold the truth quietly in our hearts, or do we need to find the courage to speak? If we are not willing to share our learning with others or if we let fear stop us from standing tall and proclaiming our truth, what is gained?

The purpose of contemplation is not to provide us with an 'easy' solution – it is to help us understand our personal truth. Often, the learning will not threaten our physical life, but rather impact on our way of life. It can call on us to find the courage to live true to self.

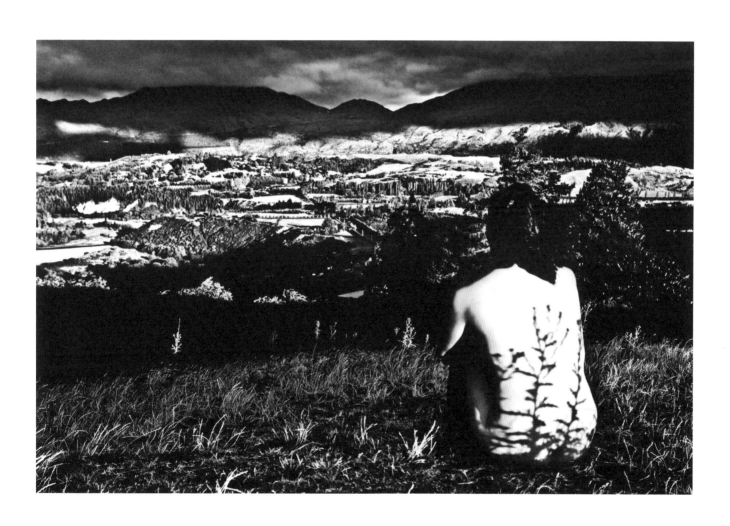

JOURNEY

If you rely mainly on logic and your mind to set your road to travel, it is probable that in time the heart will also want to have its say, and influence the path's direction. Life's journey would be so much easier if heart and mind were aligned and spoke with one voice in unison at all times.

When you encounter on your journey an unwanted, traumatic, life-changing event, it is in many respects like turning a bend and coming to a dead end – perhaps unforeseen, but requiring choice, decision and ultimately action. The road you had put so much effort into travelling is seemingly no longer available. For some

there comes the realisation that it is not a dead end, but just a roadblock to be hurdled before the chosen path can be resumed.

For others, there is the acknowledgement that a U-turn is required. Effort needs to be expended to reflect and walk back through the memories of past footsteps, before a new path emerges for exploration. Is it bravery? Courage? Perhaps. Yet, more likely, it is the energy required to commit to self, follow the heart's truth, embrace the soul's passion and have faith to journey the road less travelled towards unimagined joy – not the easy path, but definitely one that can prove to be rich and rewarding.

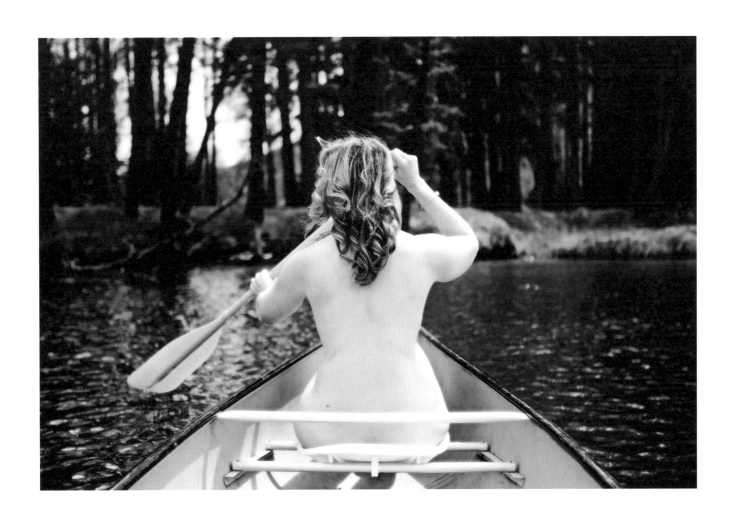

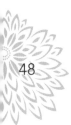

PLEASURE

As children, we are so active, in constant motion. We revel in learning what a body is capable of and how it can feel. Yet, so often in adulthood we become lethargic and resentful of expending physical energy. Have we forgotten how good it can feel?

Why are we so loath to embrace simple, physical pleasure? Our bodies are made to move, to run, jump, swim, dance and make love. The endorphins released when we expend energy in movement are pleasurable and pleasure is good.

When did you last dance until you were breathless? When did you throw your head back and shake the water free from your body?

When did you skip along a beach? When did you last climb a grassy knoll to watch the sunset?

Opportunity for pleasure is everywhere. It is the Sunday afternoon spent luxuriating with a lover in bed. It is having your feet massaged at the end of an endless day. It is the cup of tea warming your hands in the middle of a winter's chill. Pleasure is bodily, physical and of the senses. It is something that we deserve to experience every day. It is this experience of daily pleasures, big or small, that adds great joy to life.

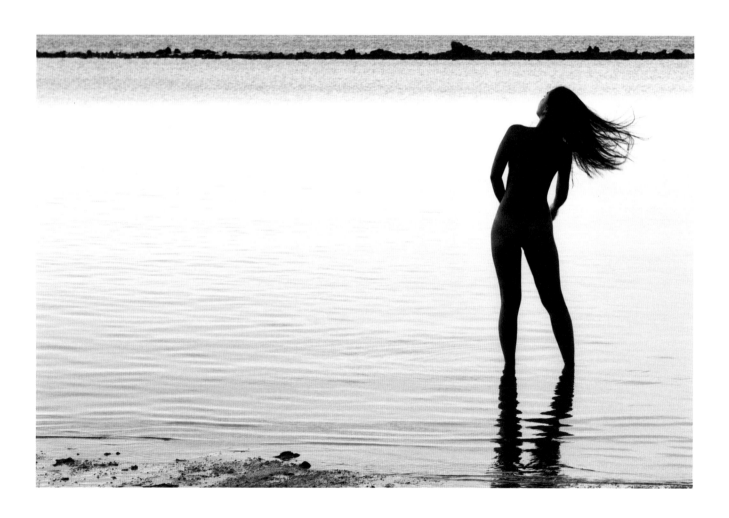

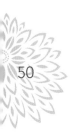

JOY

Have you ever experienced total joy, that feeling of innate happiness and delight? Total joy has the ability to render every fibre of your body, mind, heart and soul blissful and at peace. It lights your face with a beaming smile and shines with passion in your eyes. Total joy fills you with an extraordinary energy for life and living.

Like love, joy is often something that we cannot go looking for. It finds us, often after we release energy, or when we push ourselves to do something we did not think possible. It is a special emotion, to be cherished on arrival, shared when possible and accepted for its fleeting nature.

Joy does not mean that you have not felt nervousness, frustration or impatience. It does not mean that you are blind to those around you or to your environment. It just enables all of these issues to float away into the background – even if just for a while. Joy is what helps balance out the hardships and mundane aspects of daily life. It is a reward for choosing to live life with passion.

As children we experience joy frequently – from blowing out candles to showing off a new drawing, everything has the potential for joy. As adults, however, we often stop expanding our creative selves or trying new experiences. We can become lazy. In the face of perceived fear we can create self-imposed limits and boundaries and restrict our expression to the rules of society. We can conform to 'accepted' behaviours and tell ourselves of all the things we 'should not' do. Why then are we surprised when our opportunities for joy diminish? Is it really that hard to choose to live?

A life without joy – is that what we want for our soul?

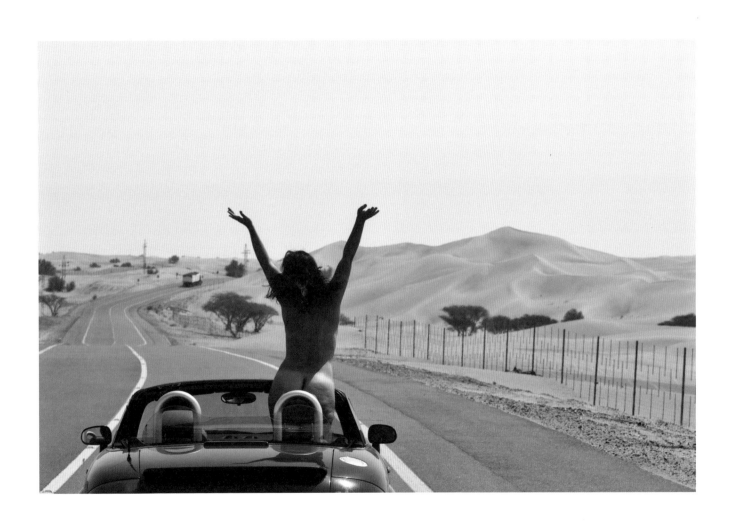

PERCEPTION

Perception is akin to wearing a pair of glasses: it changes the way we see the world and our view of reality. Our individual perception is shaped by the life we have led, the society we live in and our dreams for the future. While some may view with a critical eye and seek to find fault in the detail, others may view with a forgiving eye and choose to admire the totality of the whole. Some may be impressed by size, others derisive of the arrogance it portrays. Everybody's perception of reality varies – that alone is true.

Yet, if you only ever look at something from one perspective, how can you ever appreciate another's point of view? In a multifaith, multicultural world, surely we need to consider multiple perspectives. It's hard to do, and takes energy to set aside preconceived notions, but this is what is needed to foster greater understanding. We don't have to condone all the choices others make, but we should at least be open to considering their point of view. There is no harm in widening our perspective, no danger in being considerate of another. Ultimately, we don't have to agree.

It can be difficult to grasp the depth of perspective. Is it one or multidimensional? Is it just a hollow projection or is a person's perception affected by multifaceted influences? It is easy to regard a superficial mask, but harder to comprehend the intricacies that history, religion and culture bring to bear on a person's perception.

When we look at a Star of David, crucifix or crescent moon, what do we see? One perspective sees them as simple emblems of a faith that nourish the soul; another perspective recognises that they are symbols of two thousand years of persecution, power, persuasion, passion and prayer. Both perspectives affect choices, actions and perception. The question is: do we possess the necessary humility and compassion to consider a perspective other than our own?

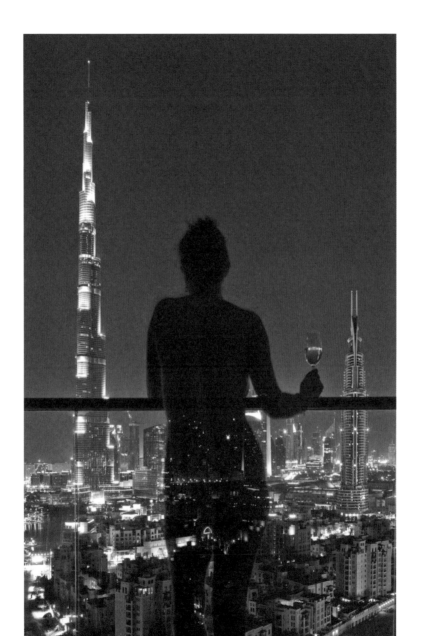

REFLECTION

Emotional intelligence reflects our ability to identify, understand and control both our own and others' emotional responses. It is a common trait among great leaders, developed through reflection. When we take time to stop and reflect on a situation (what happened, how you handled it and what the outcome was), then we are also investing in the growth of our emotional intelligence. If we can learn to manage our emotional responses, we can start to achieve a desired outcome.

Reflection is hard. It requires us to be honest, to accept responsibility for our own behaviour without assigning blame to another. Only through reflection can we begin to see how our actions and behaviours affect others and create the situations we find ourselves in. Reflection is about learning and growing, and building our ability to handle similar situations in the future. As well as being a great skill to have in the business world, it's also an essential skill for our personal life. It is challenging to our egos!

Some people have an extraordinary habit of continually making the same 'mistake' – it's as if they have not learnt. More likely, they do not possess the emotional maturity to reflect on the actions that continually result in the repeated outcome. To change a situation and stop it from recurring, we need to first change how we choose to behave.

Like any new behaviour, it takes time and experience to master the art of reflection. It takes a commitment to self-development and a belief that you are worth the effort. If you are not happy with your present and want to create changes for your future, the first step is to reflect on how you came to be where you are today.

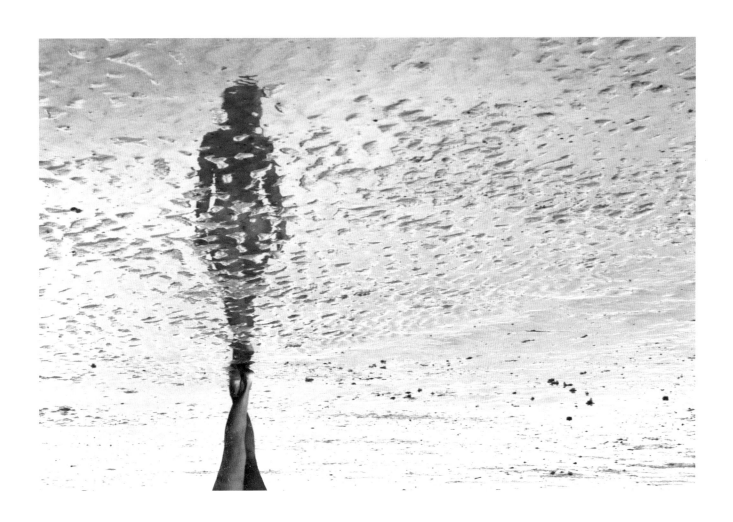

PROGRESSION

Life is an extraordinary journey. Whereas the stages of life are common to us all, the individual's evolutionary path is what creates their unique journey. The intrigue and complexity of life is determined by how we evolve in response to unforeseen circumstances: the things we do not choose, the things we would never have wished for; the negative influences on our lives that impact on us and set us spinning on a completely different trajectory than the chosen one we happily inhabited.

This is when we have to reach deep within to face fear, find courage and seek the resilience to let go of old dreams and begin a new path. The miraculous thing is that if we find the courage to work through our grief and start to let go of the past, then we often find life has in store dreams we had never conceived – a new career, a new love, a new destination.

Admiration abounds for those who have faced adversity, or great tragedy, and found the strength to overcome its impact. The 40-year old widow left to raise four young children – she cares for their grief and welfare, but wisely chooses to also be considerate of her own well-being. The loyal wife abandoned after 33 years has a choice – to be angry and bitter, or resolve to focus on her own happiness. Not only will she survive her husband's desertion, she will thrive. Her choice to live to the fullest is her gift to self.

Choice is our greatest freedom and a path to evolution. Sometimes what we desire and think will make us happy is not at all what we need in life, and our inability to let go can slow our evolution to a more fulfilling life. We must make a conscious decision to release the past in order to move into the future. Life does not owe us. There is no requirement for 'happy ever after'. Rather life provides us with challenges to face. We ask 'Why me?' and life answers 'Why not?' Without these challenges, the soul has no opportunity to grow and develop. It is true that 'What does not kill us can only make us stronger' – but only if we so choose!

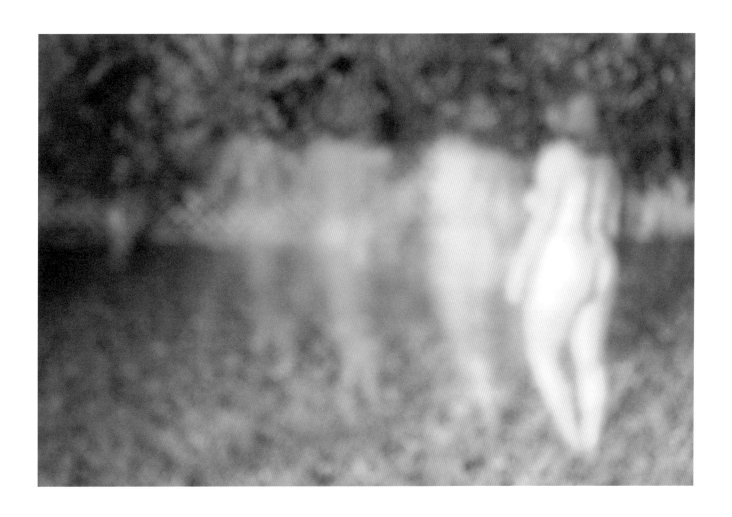

BALANCE

Within us all live two voices – that of ego and that of soul. For many of us, it is the voice of ego in our heads that seeks to dominate and direct. It speaks of logic, safety, fear and judgement. It is like a large mountain standing before us, demanding not to be ignored.

The soul, with its quieter voice, emits its message subtly through our feelings and our gut. It is a voice of freedom, truth and light. It does not yell, but gently nudges. It sits naked, holding its ground despite whatever avalanche the ego is directing towards it. It is the soul that has the courage to face fear and not cower.

Beauty and strength occur when a balance is struck between these two internal compasses. We need both voices to offer up their alternate perspectives to help us evaluate our life choices. Only then can we act with complete understanding. When we achieve balance between our ego and soul, it allows us in essence to become the CEO of our own life. No longer is the ego able to bully with logic, no more can the soul neglect the practicalities of life.

Balance is not easy – a learned experience for many. The pendulum swings its course between the two extremities. If we allow the ego to rule, unchecked, it can take a while for the soul to find the strength to stand up for itself.

Perhaps it would be easier to achieve balance if we stopped looking up at the might of the ego. If we closed our eyes and shielded our view from our fears, it would be less scary to speak our soul's simple truth. This shield from fear can come via the support of friends, growing our knowledge, or simply seeking help – we just need to find the strength to voice our fear and ask for help.

Balance comes when we believe truly in our self, our whole self, and we want to act for the good of our heart, our soul and our body. To act only by the soul's wisdom is to deny the beauty of the ego's logic. To act only on the ego's demands is to deny the truth of the soul's honesty.

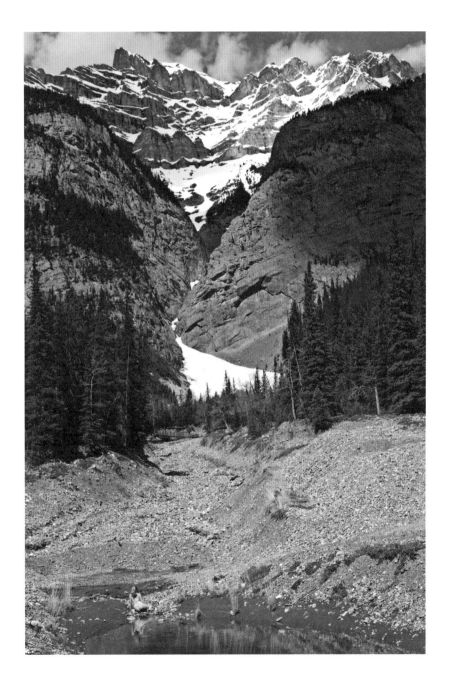

COURAGE

The ego is a wily companion. It plays on our weaknesses and our fears in order to affect our choices and our life. It reminds us of our sense of duty, of obligation, and we find ourselves exclaiming the dreaded 'should'. It uses guilt and fear to counteract our soul's wishes.

The more our soul struggles to speak its honesty, the more we are silenced by our ego. That is when we truly need to look inside for our courage.

The problem that the ego often has with honesty is that it presents truth, and once truth has been acknowledged, a decision is required. One must either decide to act, or not. Yet the decision to act often presents an unknown path and fear of the unknown can paralyse action – surely it is 'safer' to do nothing, to conform to society and the expectation of others?

Faced with a choice between two paths – the unknown and the known – the ego often seeks to cajole us into choosing the easier, known path for reasons of safety and security. What it doesn't tell us is that the easier path is often just a cul de sac that will return us in time back to this same choice. We will again reach a point where commitment to courage is what stands between us and our truth.

So, why do we let fear limit our dreams and stop us from acting on our hearts' desires? Why do we so admire the brave individual who has the capacity to look fear in the face and act anyway?

Courage is an act of honesty. It is when we acknowledge the needs and desires of others, but choose to act true to self. It is when we accept that the choice may pose risk, but realise that an alternate choice would be damaging to our soul, personal integrity and beliefs. Courage is when we choose to act with self-worth and self-belief. As Amelia Earhart[2] said:

> The most difficult thing is the decision to act, the rest is merely tenacity. The fears are paper tigers. You can do anything you decide to do. You can act to change and control your life; and the procedure, the process is its own reward.

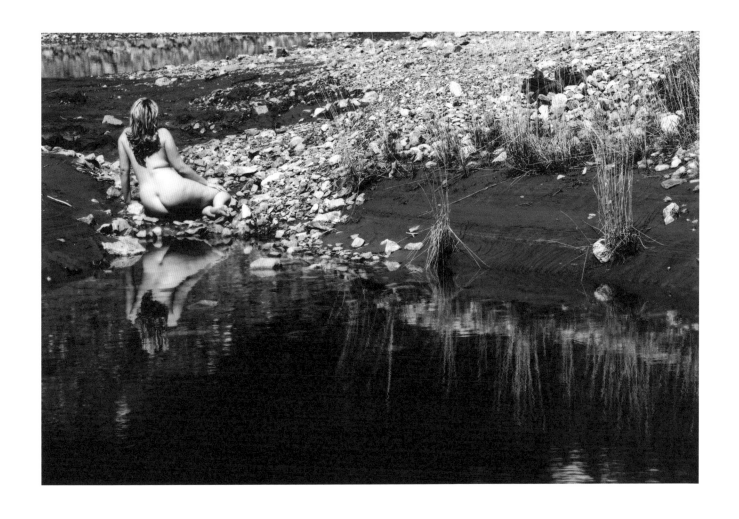

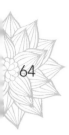

RESILIENCE

Life is not designed to be 'easy'. It challenges us with disappointments, loss and barriers. Sometimes, the experience of these challenges leaves us fragile and surrounded by the skeletons of our pain and disillusionment. In many respects, each challenge tests our resolve and resilience.

It is hard when we truly understand that despite a loving family and friends, we are each uniquely alone – and that we cannot rely on someone else to be resilient for us. Others can stand beside us to lend a helping hand, provide a shoulder to rest upon, and to listen to our sorrows, but it is our own unique self that needs to develop resilience to overcome life's sorrows and disappointments, to develop the energy within to lift ourselves up and to carry forward with our journey.

The fragility of self is a daunting thing to experience, especially in the darkest hour of the night when the ego, the body, the whole self howls its pain and sadness. This expression of agony can often leave us at our most fragile and alone – spent. There are so many clichés about when and how we find a drop of strength to wipe away our tears. Each speaks of finally reaching the point of no return; when you've fallen so far that the only way to go is up. How after the darkest hour of the night there is the dawn and the start of a new day. Clichés are cliché for a reason; they echo the voice of experience.

When we have allowed our ego the expression of its agony, its disappointment and its sadness, we reach a point of choice. Either our spirit can be so crushed that it has no desire to turn away from despair and we remain in a state of deep depression, or there is a voice deep in our soul that gently encourages us to awaken, strengthen, stretch and embrace life. Resilience is our soul's strength, born from the experience of pain that allows us to overcome adversity.

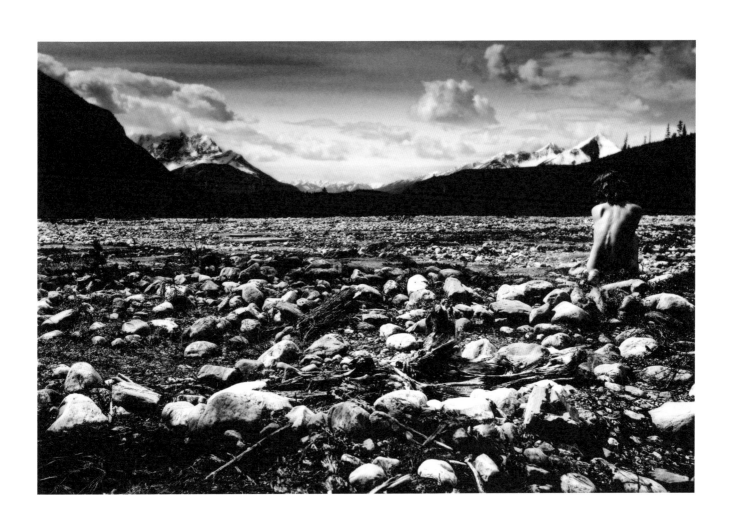

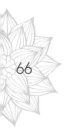

PREPARATION

Life is often described as a journey, rather than a destination; a soulful progression to know and embrace our unique selves rather than an ego-driven, goal-focused road map to a desired location.

In our early years we are encouraged to focus on goals – exams, qualifications and career. Through these goals we prepare ourselves to achieve security and define a purpose for our energies and passions as a productive member of society. The preparation of our ego's strength evolves with each life experience. It reflects our childhood and our treatment from others, the love and nurturing that we receive, the society and peer group we wish to be accepted into.

If we focus our energy on honing acceptance, will we ever achieve peace of mind? Why is it that so many of us spend hours exercising our mind and body, but commit very little time to developing our soul? Why is it that some people spend hours giving their energy and time to charity and helping others, but neglect their own health and well-being? Why does it seem so difficult to balance the use of our time? Does fear of judgement motivate our choices?

Prayer and spiritual reflection are useful tools for preparing the soul's strength. Studying philosophy, religion and the teachings of elders and leaders can only aid our soul's development. Yet, we often prefer to spend our time watching television, playing computer games and escaping into sci-fi fantasy – anything to escape our own reality.

Soul preparation, like physical fitness, takes time, effort and commitment. How can we expect to build wisdom without it?

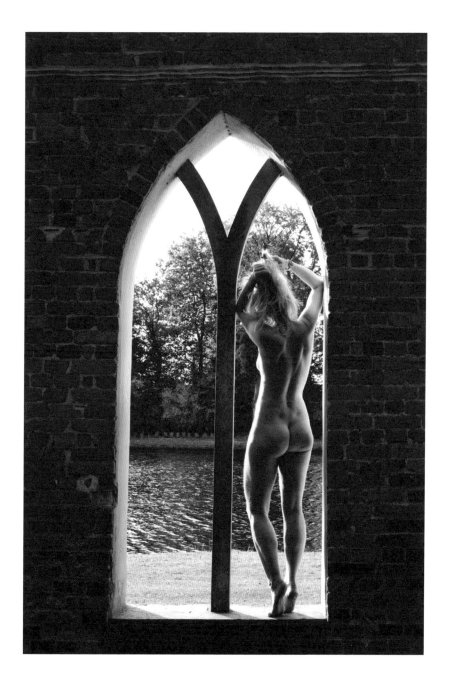

STAMINA

Some days exhaustion hangs lead weights on your arms and legs, grips your head in its vice and seeks to constrict your throat from all breath. On these days, a mere step requires the energy of a marathon, and nightfall waits at the end of eternity.

Life's drain on our energy ebbs and flows like the seasons. In times of despair, stress and hardship, when sunshine in our life is sparse, we must either find the stamina within, or seek extra energy externally. Either way, with time a battery recharge is called for.

Yet, what if escape is not feasible? Limited by funds and time, what if we have to remain on our 'treadmill'? How do we find stamina? How can we recharge?

The options are different for everyone. For some it is to sit for five minutes, hold the warmth of a cup of tea and rest the eyes. For others it is to stop constant motion, stand still for a period and watch the magic of the setting sun. Yet, the best recharge often comes through the arms of love. To rest your head and be held can fill your body and spirit with peace – an energy like no other.

A soulmate, a kindred spirit, a dear friend or a lover – the arms of love can come in many shapes and forms. Each represents the opportunity for a deep and soulful energy exchange and the easing of exhaustion. Just to know that another cares enough to recognise your state and offer rest, to know that you are not alone, can renew the energy within. A hug does not take much time or cost a lot – it only requires an expression of compassion.

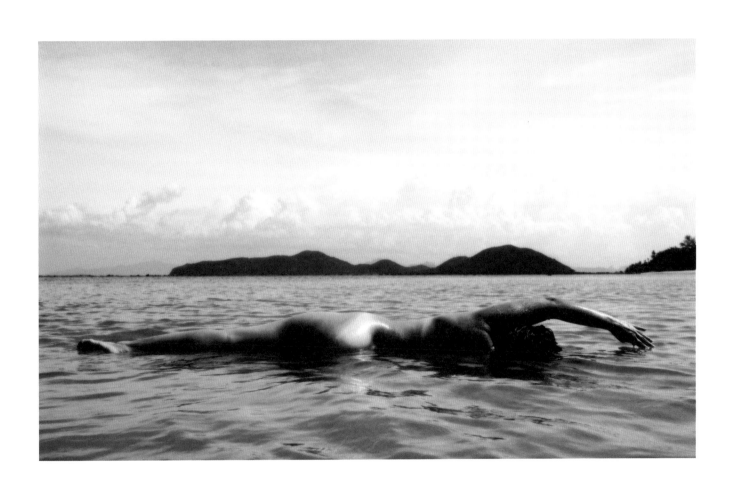

SOLACE

With over seven billion people in the world, how is it that so many of us are alone? Devoid of companionship, bereft with loneliness, is it any wonder that we seek solace through consumption? A tub of ice cream, a bottle of wine and a burning cigarette are all pacifiers for a body's craving for satisfaction, or a soul's desire for love.

If life is absent of deep happiness, it is not surprising that we would seek small pleasures where we can. The drug of choice for solace can vary, as long as a physical peace and respite occurs. We pay our money, we ingest, and hopefully the drug delivers its soothing promise. But do we recognise the day that our actions cross the line drawn between simple expressions of pleasure and a harmful habit to the body? Are we honest enough to acknowledge the effect of our choices? If we are, why do we keep hurting ourselves?

What if we were able to change our physical and mental conditioning? Could we achieve solace simply through a soak in a hot bath, or would the decades of self-abuse have eroded our ability to exercise our will power?

What if our state of aloneness were to change? Would we alter our behaviour? Could we? Why would we consider changing our behaviour for another, and not seek to make healthier choices simply for our self?

We are constantly encouraged to live in the now, entirely in the moment, and to put aside any regret about the past or worry for the future. Is this the justification that our ego uses to accept our self-harming choices, or have we already acknowledged our mortality and decided to soothe our ego with daily solace, irrespective of the impact on our longevity? Do we really care so little for our health, for our self, for our soul, and those that love us?

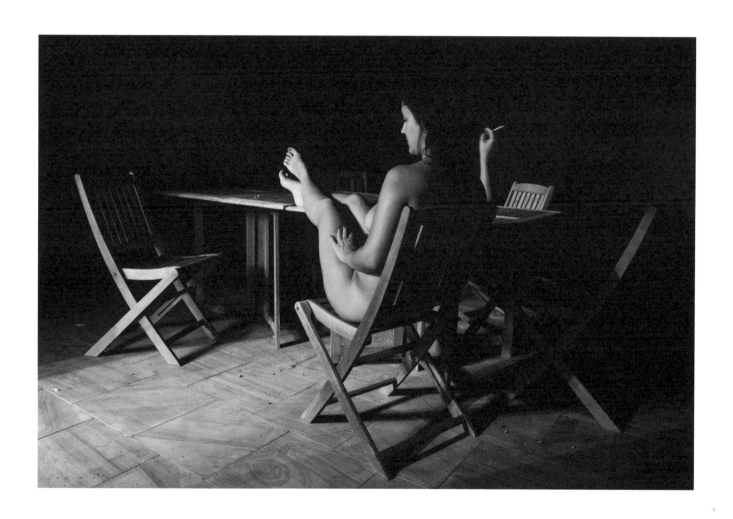

PROTECTION

As women, we are born with a natural instinct to protect and nurture. Some of us are fortunate enough to embrace this instinct in the role of motherhood. For other women, that instinct reveals itself in our career choices and community commitments. There is something so primal and fulfilling in the giving of protection and caring for the fragile or less fortunate. It is a time when we think less of self and more of others, when we set aside our ego and embrace the love in our soul.

The difficulty comes when there is the understanding that protection is no longer desired or needed. When the time comes to let go and allow a person to stand on their own. The ego blazes its fear and insecurities. How will the person cope alone? How could they survive without you?

It is the soul that gives us the strength to let go and allow a person to walk their own path. The soul reminds us of all the lessons we have taught and gives us faith that protection is no longer needed.

At the point of separation, we need to believe that we have done all that we could. The question remains as to how we have prepared ourselves for the grief and loss of separation. As mothers, have we given all our energy to our children, neglecting spouse and career, or have we been soul-balanced with the wisdom to tend to each aspect of our lives? It takes soul-strength to balance our desire to protect, with our need to let go. As Robert Paul Gilles Jr[3] wrote:

> To "let go" is to admit powerlessness,
> Which means the outcome is not in my hands.
> To "let go" is not to judge, but to allow another to be a human being.
> To "let go" is not to regret the past, but to grow and live for the future.
> To "let go" is to fear less and to love more.

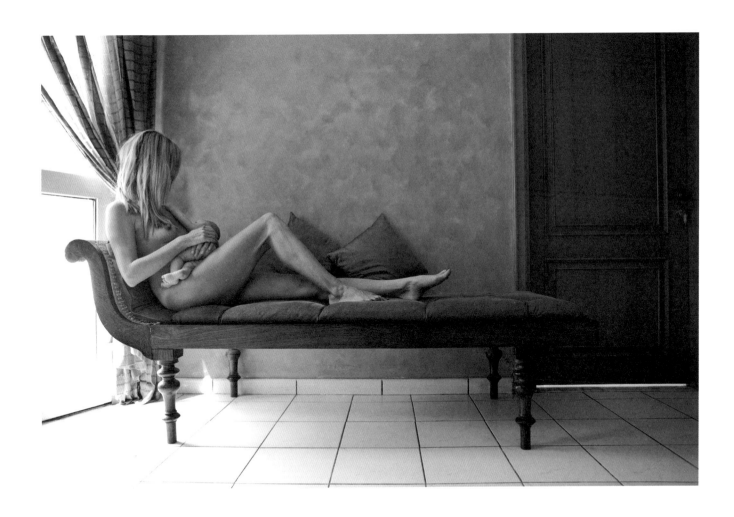

PATIENCE

Two of the hardest words in the English language to comprehend, accept and master are 'no' and 'patience'. Such simple words, yet words that many of us often struggle with.

In our desire to be accommodating and to please others, we often avoid saying 'no'. Perhaps we think we are being selfless, when in fact we are often hurting ourselves. 'No' is a word that allows us to stand up for our self-worth, our self-esteem, and to set the boundaries of behaviour that are acceptable to us. It is not wrong to say 'no'. It is a hard word to learn to say, but ultimately it is empowering and reflects a sense of self.

Equally, learning the art of patience is difficult. Mother's words echo in your head 'to hold on around the bend' and that 'all good things come to those who wait'. Often the holding on and the waiting are endless, excruciating and painful. It is hard to accept that we cannot have all we desire right here and now. We rail against the need to act with patience. Yet in doing so, all we achieve is self-induced angst, frustration, disappointment and suffering. Perhaps it is true that there is a time for impatience in our lives, but there is also, more importantly, a time for patience.

How do we learn to accept the flow of nature, the seasons and time? How do we know when it is time to run and time to sit? Is it our ego that yells for action, results and fulfillment – NOW? Is it our soul that gently encourages us to sit, with patience, until a storm has passed? Perhaps our acceptance and appreciation of patience finally comes when we are able to listen to both the voices of ego and soul and instinctively know which voice speaks with the truth for our greater good. If nothing else, learning patience helps us to find peace in the now, and with reflection appreciate all the blessings that we do have.

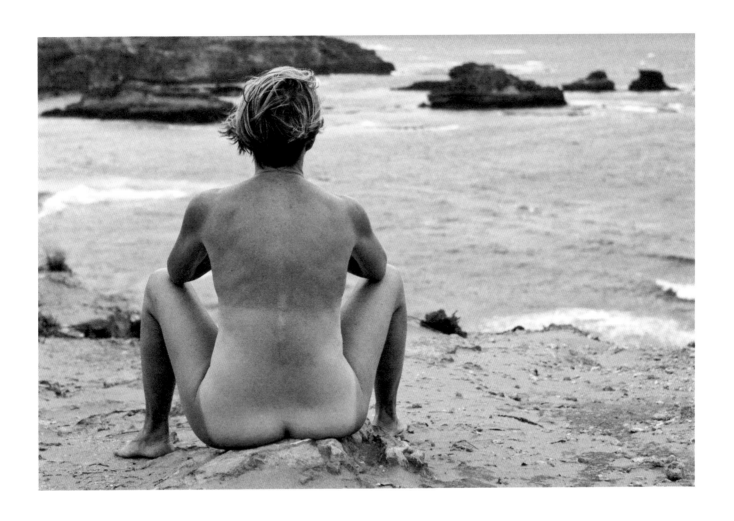

PEACE

St Francis of Assisi, a thirteenth-century monk, prayed:

Lord, make me an instrument of Thy peace,
Where there is hatred, let me sow love
Where there is injury, pardon,
Where there is doubt, faith,
Where there is despair, hope,
Where there is darkness, light,
And where there is sadness, joy.

O Divine Master,
Grant that I may not so much seek to be
consoled as to console,
To be understood, as to understand,
To be loved, as to love,
For it is in giving that we receive,
It is in pardoning that we are pardoned,
And it is in dying that we are born to eternal life.

Reading his words, it is evident that St Francis made choices to fully embrace his soul and live true to self. Very few, if any of us, will have the conviction to live a saintly life, yet perhaps there are some aspects of his behaviour that could help bring peace to our own lives.

If we were to premise our actions and choices on sowing love, giving pardon, restoring faith, offering hope, shedding light and embracing joy, then perhaps our soul and our ego could operate in peaceful harmony. Perhaps if we focused less on trying to achieve world peace, and more on living with inner peace, we could incrementally reduce the angst, fear and hatred that permeate our world.

Peace is the feeling that we have when the noise in our heads is quiet, our hearts beat gently, our souls are guilt-free and our bodies are at ease. Peace comes when we live true to self and in harmony with others.

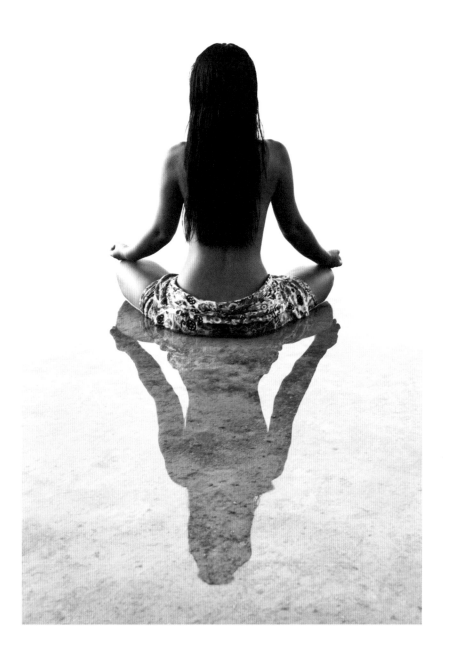

FREEDOM

In life, we often perceive ourselves as 'tied down', when in actuality we are not. We see the demands of a job, a family and other commitments as holding us back from what we would rather be doing, when often this is not the case at all. Mostly, it is our own choice of attitude that makes us feel imprisoned.

Why is it sometimes easier to perceive our lack of freedom? Why does the truth of freedom frighten us, and our sense of security? There are many accounts of people limited by commitment or ability accomplishing extraordinary feats and achievements. These people do not perceive that their circumstance binds them to a certain way of life. It is the attitude and will power of the amputee that gives them the freedom to excel as a Paralympian and the drive of the mother of three with a full-time job to also 'make the time' to complete her university degree. Freedom abounds when you decide to live a life true to self and to make the sacrifices and commitments necessary to do so.

Indeed, it is our understanding of our uniqueness that also frees us to be our true self. We do not need to compare ourselves to others. Our journey is ours alone. Surely, one of the central goals in life's journey is to journey inwards to embrace our soul and be ourselves When we purely focus on being the best we can possibly be, then we are truly free of the 'ropes' of societal expectation and old behaviours.

Freedom comes when we love ourselves. Freedom comes when we embrace an attitude to voice our dreams, face our fears and strive to make our dreams become our reality. The only question is, how much do we want our dreams to come true? How much do we want the peace of freedom and to quiet the demons in our heads?

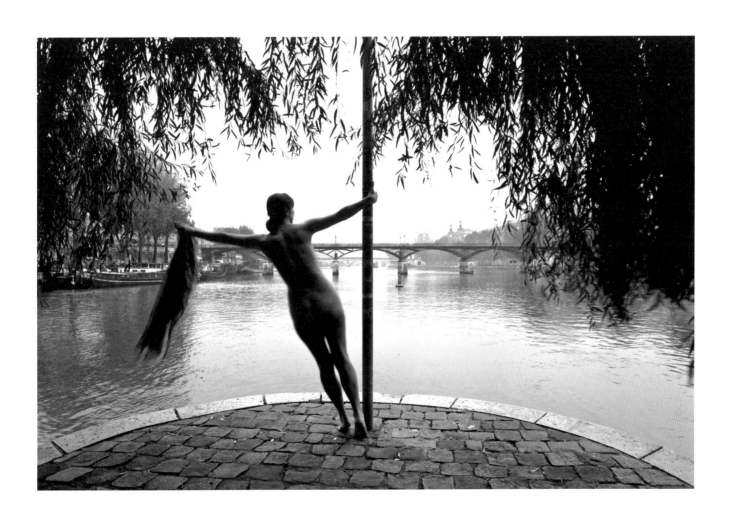

FEARLESS

For centuries, people have challenged the status quo, fought against control, and been relentless in their pursuit of equality and respect. At each stage of the equality evolution, strong, resolute individuals found the courage to speak their truth, were unwavering in their commitment to their beliefs, set aside their own fears, and demanded the right of freedom.

In 1913, Emmeline Pankhurst[4] spoke of 'Freedom or Death' and championed for the right to vote. Fifty years later, Betty Friedan[5] focused the inequality debate on family and the workplace. Their individual resilience and bravery helped foster behavioural revolution in the West and led to freedoms that are today our legal right.

Yet, many people are still subjugated by societal and religious controls, and for them change is measured in infinitesimal steps. Their hope flickers bravely, but can flare in strength when an individual (such as Malala Yousafzai[6]) courageously chooses to face death, rather than give up a fight against control.

The fight for equality reinforces our understanding that the evolution of deep change requires many cycles of revolution, each centred on the energy to 'rally – rejoice – rejuvenate – reflect – and rally again'. In a small measure, this same process of revolution applies when we grapple with the inequality between the voices of our ego and soul, and seek to change our own behaviour.

When it is our soul that has been abusively downtrodden by our ego, it is time to 'rally the troops', pen a personal liberation anthem, commit to the 'cause' of change, and to be fearless in the pursuit of equality for our soul. The roar of this revolution is not created by a big number of followers, it needs just one soldier – you.

Once you have voiced in your soul that it is the time for change, you can no longer pretend or ignore your truth. You may hesitate in your resolve, but it will probably just be a moment's hesitation as you garner the courage to face your fear.

As your soul strengthens, your ego will come to accept that it can no longer keep you down or silence your truth. It will acknowledge your fearless state and that it is your time to fly free from its control.

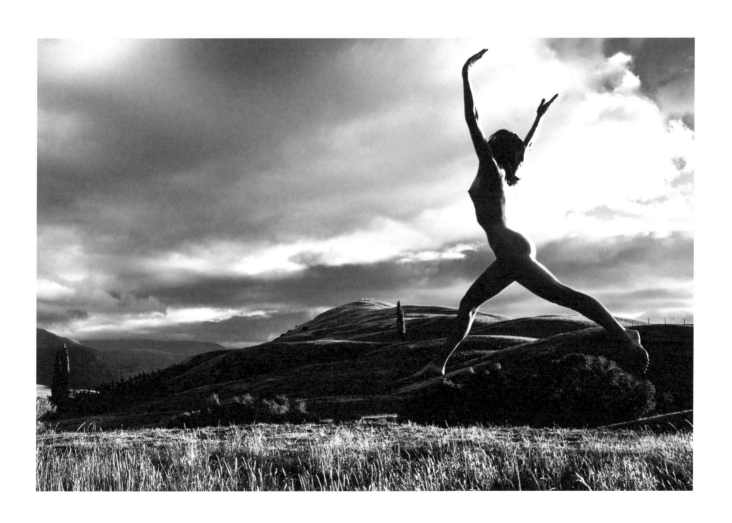

STRENGTH

Just as pre-flight safety checks are performed on an aircraft, a soul preparing to soar in flight needs to 'safety check' the resilience and flexibility of its backbone. When we choose to fly, we will be buffeted by many winds, and be a target for numerous opinion-laden missiles. It is only our inner resilience and flexibility that will provide us with the strength to bend (but not break), as we face each new circumstance, criticism and claim for control.

This does not mean we need to take an intensive course in yoga before we garner the courage to face our ego's fears! We just need to understand our soul's depth of conviction for change. Are we truly ready to change our behaviours and choices? Are we ready to listen to our soul and weather a storm of judgement?

However you approach soul freedom, be it via a disciplined commitment to strength training, or an impetuous moment of choice, the result can only be positive. If you soar, you will experience the joy of freedom. If you fall, you may bruise or crumple in a heap, but you will heal, learn from your mistakes and be stronger next time when – no longer a novice – the risk of self-sabotage by the ego reduced.

You alone get to decide what your soul's goal is. You determine how much resilience you hold in your soul to face your ego's fears, and bounce back from disappointment. It is your own attitude that will eventually determine your ability to succeed in balancing the voices of soul and ego and decide if you have the backbone to live a life true to self.

As adults, we often deride the existence of magic. We speak of it as a childish con, a slight of hand to trick and fool – not something real or tangible. We are wrong. Magic is real. As Goethe[7] said:

> *Magic is believing in yourself!*
> *If you can do that you can make anything happen!*

The important question is: do you believe in yourself? Do you have faith in the strength of your soul?

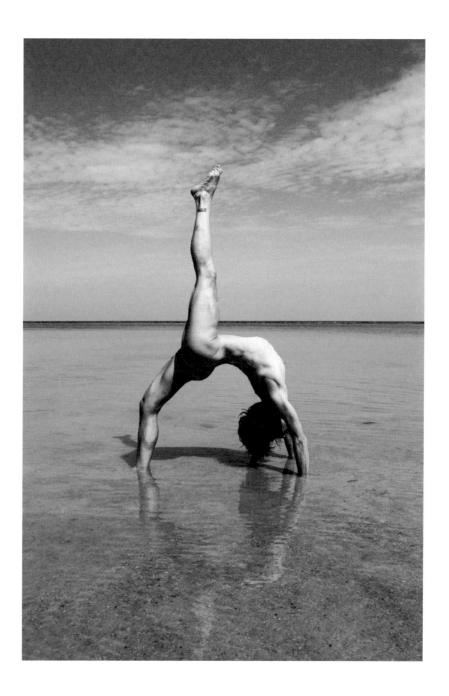

GROWTH

It's funny, peculiar even, how often good things happen and opportunities arise once you make a shift in your beliefs, choices and actions. It is almost as if the Universe is now able to shower you with the blessings it had stored away, as it waited for you to grow and mature.

When good tidings bountifully flow, you cannot help but awake with a smile on your face, hungry to experience the day ahead. The urge to stand tall and bask your body in the morning's glory is strong. The desire to spread your grateful arms across the land is immense. You want to proclaim your readiness for the next challenge, fearless of the future. You want to keep experiencing the wonder of growth, the magic of life. You shine with the light of inner peace, and feel happy.

It's hard sometimes for others to watch a person who is blossoming. They are sometimes resentful of your perceived 'windfall', and feel the need to be biting with their sarcasm, scathing in their bitterness. It is not about you. More often than not, their attitude is merely a reflection of how they are feeling about themselves, and their lack of growth. You may not be able to make them understand; perhaps all you can do is offer compassion.

The reality is that when you start to experience the rapture of soulful growth, you know in your heart that you are still very much an embryo with a long way to go before you reach full maturity. Yet, that is part of the energy and excitement, because you know that you are merely at the start of an incredible new journey.

You know instinctively that the road ahead will not be easy. You know that there will be times when you will get disorientated, stumble and fall. Yet, this knowledge is counterbalanced by a quiet self-confidence that you will listen wisely to both the voices of your ego and soul, trust in your choices and seek forgiveness when required.

How far you choose to travel depends entirely on you and the energy you commit to growth. If you tire, you need only ask yourself one question: 'Do I want to be all I can be?'

WISDOM

The development of wisdom has been challenging man for over 2500 years. Confucius'[8] personal philosophy was that:

By three methods we may learn wisdom:
First by reflection, which is noblest;
Second by imitation, which is easiest;
And third by experience which is the bitterest.

Unfortunately, it often seems that the noble and easy routes elude us, and our wisdom is born of pain. There is no shame in this, it just is. Far better to have suffered and grown via pain, than to choose to sit immobilised by sadness and loss.

In life, bad things happen, and we hurt. It does not matter if pain came via our own mistake, the action of another or circumstance. It is how we choose to respond that will define both our character and the future quality of our life. We have a choice.

There may be a price to pay, forgiveness to offer or an acceptance to embrace. We have the freedom to choose our attitude, to develop our wisdom, and to decide if and how we will arise from this experience. At times of challenge, there is much to be gained. It is an opportunity to embrace the soul's learnings and focus on resilience, hope and strength.

It is also when the soul needs to protect the self from internal danger. When the ego faces pain, it can struggle. Its pride may be damaged, or it may feel fragile and vulnerable. To guard against gossip and judgement, the ego can seek to don a mask of invincibility, and to repel all gestures of concern and care. It may decide to retreat and live a hermit life. We can only hope that our family and friends have the compassion to see behind the mask, and lovingly remind us that we are not invincible, we are mortal, and deserving of kindness.

In the midst of pain we need to remember that it is not weak to ask for help – it is simply an expression of our soul's wisdom.

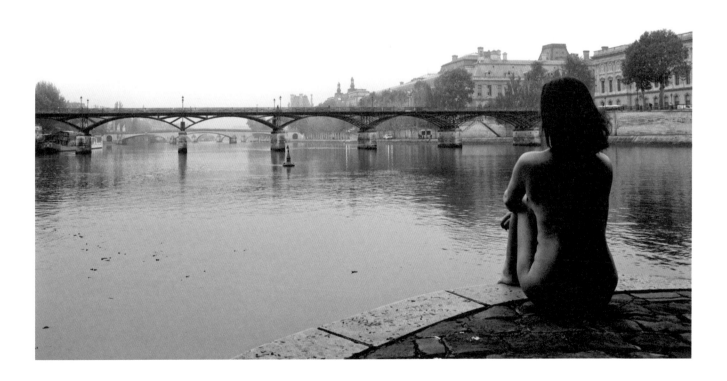

REVELATION

When we choose to awaken and journey along a path of soulful growth, we unconsciously know that at some point the changes in our behaviour and choices will be noticed by our family and friends. They will observe our new attitudes, hear snippets of our garnered wisdom, and come to realise that we no longer fit inside the box that we had traditionally been pigeonholed into.

It is not surprising then, that like any great work, the time will come to reveal ourselves in our full beauty, and share all that we are with those we love. It does not mean that we need to parade pompously through the streets like the Emperor in his new clothes[9]! If we did, we would merely reveal our foolishness.

Rather, we can quietly and humbly reveal ourselves openly and honestly through our words and actions, maintaining our acceptance that there will continue to be days when our behaviour reflects our growth, and times when we will err.

It may take a while for others to accept our changes and to let go of old, preconceived notions of who we are, and how we had previously chosen to live our life. That is for them to deal with. It is not our responsibility. Soul growth enables us to no longer conform to others' preconceptions.

The beauty of choosing to live true to self, in the balanced harmony of ego and soul, is that you constantly project your self-confidence, self-esteem and self-acceptance. Your inner light shines and eclipses any possible negative, ego-judgement of your physical self. You exude strength, surety and sensuality. Your inner peace provides your patience, and your wisdom guides your words. Naked or clothed, you are serenely accepting of the fact that you are a unique and magnificent human being – an image of self-love.

It's not surprising that others can become captivated, and seek to learn the 'secret' of your transformation. How incredible to be able to tell them that the change reflects your conscious choice to value self!

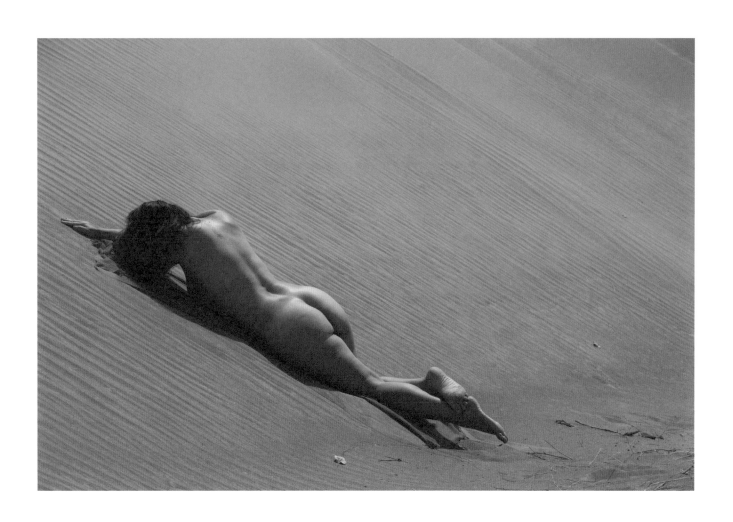

CHOICE

If I knew then,
 what I know now,
Would I change a single thing?
Would I change the life I've led?

If I know now,
 what I could have,
Would I change a single thing?
Would I change the life ahead?

If I am love,
 what love am I?
Would I change a single thing?
Would I change the 'me' I love?

If I am truth,
 what truth am I?
Would I change a single thing?
Would I change the truth in me?

If I have choice,
 what choice is mine?
Would I choose to love my soul?
Would I choose to live my truth?

what is your choice for self?

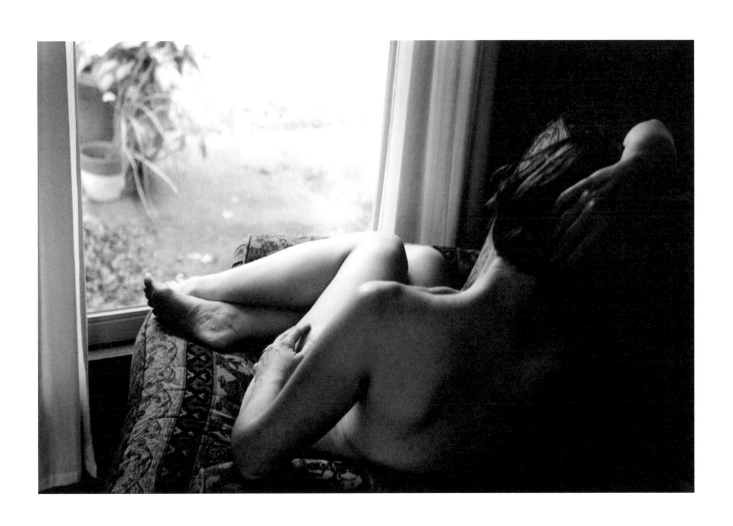

LIBERATING SELF – EPILOGUE

A reality of life is that the things we treasure often require expenditure of energy to maintain their appearance, value and longevity. Whether it is the regular effort of weeding and pruning to maintain a garden's beauty, or the annual 'spring clean' to care for the upkeep of a home, both activities speak of care, consideration and devotion. The two alternatives to committing your own energy would be to pay for someone else to do the maintenance for you, or to leave these treasures unattended to wither, deteriorate and be lost. As with all things in life, we have a choice regarding the path we wish to take.

When we choose to treasure our self and embrace our soul, the same principal of energy expenditure applies. There will be times when we need to commit a lot of energy to face fears, find courage and balance the competing voices of ego and soul. At other times, we may just need to speak gently with our self to soothe perceived worries or flame hope. When we live in a state of self-acceptance, self-worth and self-love, we will come to know the ebb and flow of energy required to maintain the beauty of our unique self. We will also quickly learn that self-maintenance is not a task that we can pay someone else to do on our behalf! Employing a therapist or buying a book can help, but the expenditure of money alone will never negate the truth that we have to take care of our own soul, ego and self.

The other truth that we will come to understand is that living permanently in a 'state of liberation' will take regular effort, commitment and passion – it is not a one-time effort! Like all aspects of self-care, be it physical fitness or mental health, our spiritual wellness is best achieved with daily devotion and a balanced 'maintenance plan'. It is your choice – only you can decide what effort you are worth.

The choice, once made, will come to represent threads added to the fabric of life. For some of us, the daily choice will be big, bright and colourful – the threads speaking of our passions, adventures, risks and rewards. For others, the tapestry may be monochromatic and devoid of textural variation, often a reflection of choices limited by fear, judgement or aversion to risk. Neither choice is right or wrong – merely a testament to how we opt to live life and value self. We have no right to judge another's choice, for we will never fully know their perspective, environment, history, fears or obligations. The very least we can do is be supportive.

Liberating self is not about being selfish and self-centered; rather it is about embracing self-awareness, self-worth, self-esteem, self-confidence, self-acceptance and, most importantly, self-love. It is when we value our unique self – both ego and soul together. It does not mean we will never feel fear again. Instead, we will come to know that fear is just the ego seeking an easier, quieter path, and when our soul needs to garner courage to face a 'paper tiger'. For to live in fear is to limit opportunities for the soul's growth and life's joy.

If we can embrace soul and live with compassion in our heart, we can balance our ego's needs and be accepting of the good choices and mistakes we make during our life's journey. Only then, having liberated our self, will we know the wisdom of Kahlil Gibran[10]:

> *To measure you by your smallest deed is to reckon the ocean by the frailty of its foam.*
> *To judge you by your failures is to cast blame upon the seasons for their inconsistencies.*

Oh peace, oh serenity
To stroll in harmony with life's flow
And gaze at the glory of a blazing sky.
To recall William's words — 'To thine own self be true'
And have freedom's torch flare in tribute
To the soul's love and liberation of self.

— Battery Park, May 2013

CITATIONS

ONE: Energy

Theodore Roosevelt

'Citizenship in a Republic' Speech, Sorbonne, Paris, France. 23 April 1910. Theodore Roosevelt Papers at the Library of Congress. Library of Congress. http://www.theodorerooseveltcenter.org/Blog/2011/April/21-The-Man-in-the-Arena.aspx. Theodore Roosevelt Digital Library. Dickinson State University.

BrainyQuote.com, Xplore Inc, 2013. http://www.brainyquote.com/quotes/quotes/t/theodorero103499.html, accessed 1 April 2013.

TWO: Courage

Amelia Earhart

http://www.ameliaearhart.com/about/quotes.html. CMG Worldwide – estate of the Family of Amelia Earhart.

THREE: Protection

Gilles, Robert Paul Jr. 1996. *Thoughts of the Dreampoet: Vol.1.* Library of Congress, USA.

FOUR: Fearless

Emmeline Pankhurst

Emerson Kent.com, 2013. http://www.emersonkent.com/speeches/freedom_or_death.htm, accessed 30 March 2013.

FIVE: Fearless

Friedan, Betty. 1963. *The Feminine Mystique.* New York: W.W. Norton.

SIX: Fearless

Malala Yousafzai

CNN.com, 2013. http://edition.cnn.com/2012/11/10/world/asia/pakistan-malala-one-month, accessed 30 March 2013.

SEVEN: Strength

Johann Wolfgang von Goethe

BrainyQuote.com, Xplore Inc, 2013. http://www.brainyquote.com/quotes/authors/j/johann_wolfgang_von_goeth_2.html, accessed 30 March 2013.

EIGHT: Wisdom

Confucius

BrainyQuote.com, Xplore Inc, 2013. http://www.brainyquote.com/quotes/authors/c/confucius.html, accessed 30 March 2013.

NINE: Revelation

Andersen, Hans Christian

Fairytale of 'The Emperor's New Clothes', Hans Christian Andersen Center. Andersen.sdu.dk, 2013. http://www.andersen.sdu.dk/vaerk/hersholt/TheEmperorsNewClothes_e.html, accessed 30 March 2013.

TEN: Epilogue

Gibran, Kahlil. 1923. *The Prophet*. New York: Alfred A. Knopf Inc.

Goodreads.com, 2013. http://www.goodreads.com/quotes/191453-you-have-been-told-that-even-like-a-chain-you, accessed 30 March 2013.